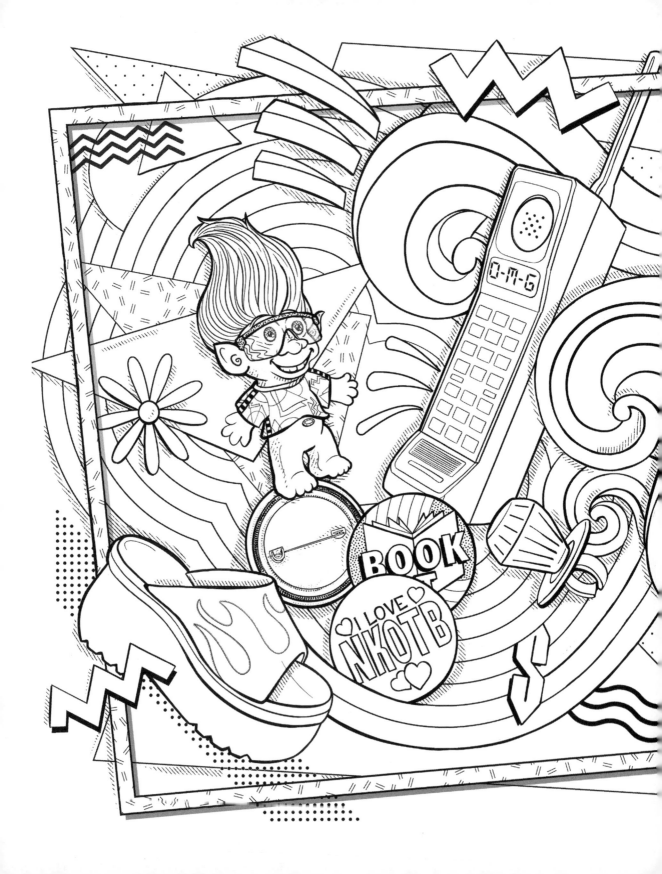

totally '90s coloring book

christina haberkern

PLUME

PLUME

An imprint of Penguin Random House LLC
penguinrandomhouse.com

Photographs courtesy of the author.

LIBRARY OF CONGRESS CATALOGING-IN-PUBLICATION DATA
has been applied for.

ISBN 9780593184769 (paperback)

Printed in the United States of America
10 9 8 7 6 5 4 3 2 1

introduction

I'm so excited to bring you my first coloring book written under my own name, *Totally '90s*. This book is a trip down memory lane and showcases some of my favorite trends and flashback moments that surrounded my youth, growing up in the '90s. My work has always been inspired by iconic pop-culture moments and this book represents where my fascination all began.

Ever since I was a little girl in Northeast Philadelphia (born and raised!), I was drawn to everything silly, weird, and in between. In the mid-'90s I was an awkward teen who wanted to sit with the cool kids, but with my glasses, braces, and paint-covered overalls, I was definitely more Josie Grossie than Kelly Kapowski. I would spend hours at my kitchen table with a giant pack of crayons and pour myself into whatever coloring book I could get my hands on.

As an adult, knowing the positive effects that coloring books have on people has inspired me to make my own. I'm thrilled and honored that I get to share my work and sense of humor with so many people. I may have grown up, but not on the inside. I'm still that same art-nerd pop-culture fanatic.

I hope you enjoy all the fun, trends, and silliness of *Totally '90s*.

COLORING TIPS

♡ This book is meant for all ages and skill levels! Use crayons, markers, gel pens, or whatever you have! Don't be afraid to mix your materials. There are no rules! Don't be afraid to color outside the lines or use every color of the rainbow.

♡ Use the test page in the back of the book to test the colors of your markers or gel pens.

♡ When coloring with a marker, place a piece of thick paper under the page to prevent the color from bleeding through to the next page.

♡ Most important, HAVE FUN!

Without Pinterest and social media influencers to guide me, I relied on what I saw on-screen to figure out my own personal style. The '90s gave me so much style inspiration, thanks to Clarissa Darling, Blossom Russo, Hilary Banks, and Kelly Kapowski. For me, no one had a better fashion game than Cher Horowitz and her friends from *Clueless*. Cher was a doll come to life and her aspirational wardrobe made her a total style icon. As an awkward teenager, I could daydream and picture myself in my very own Beverly Hills bedroom with an endless number of designer pieces. Who needed to be a plain Jane when you could be a plaid-clad Beverly Hills teen with your very own computer-organized closet? While the decade gave us some unfortunate looks, like flower bucket hats, side ponies, and snap bracelets, Cher gifted us with timeless looks that will always be peak style goals.

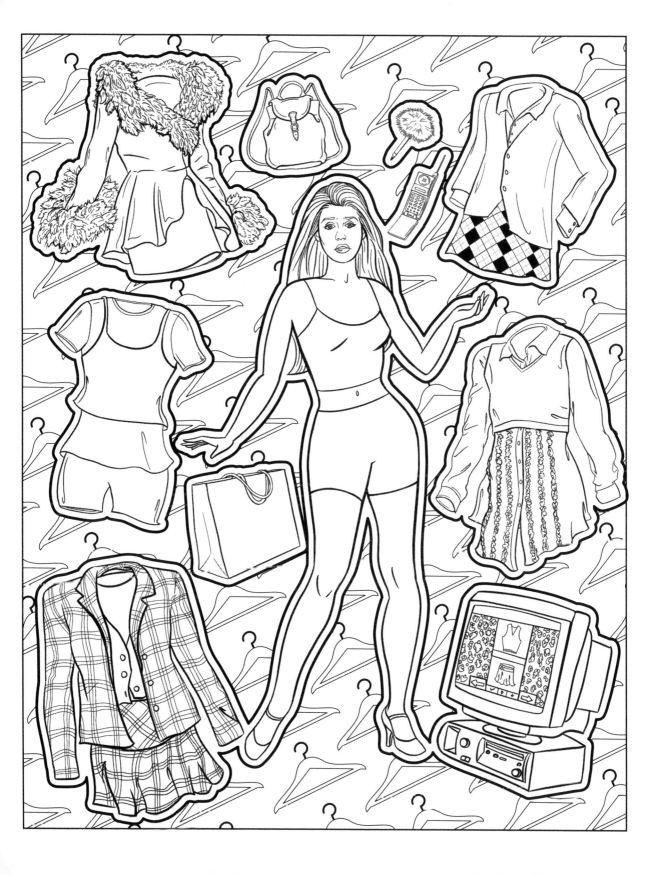

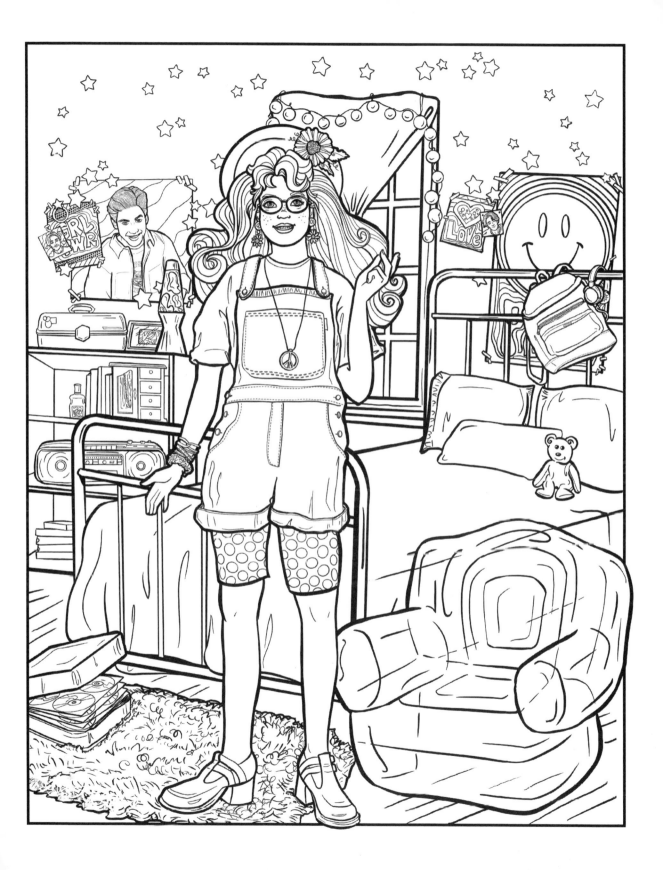

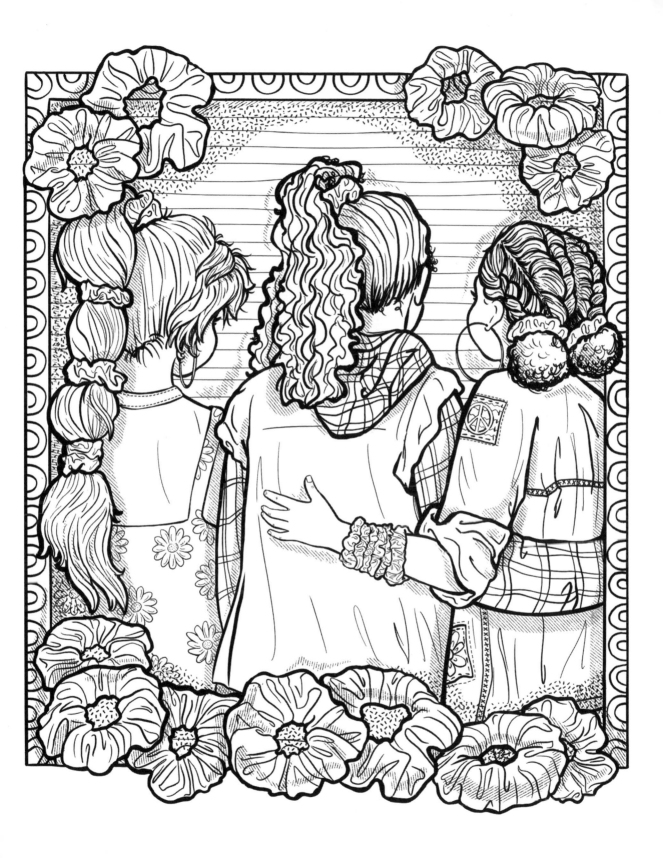

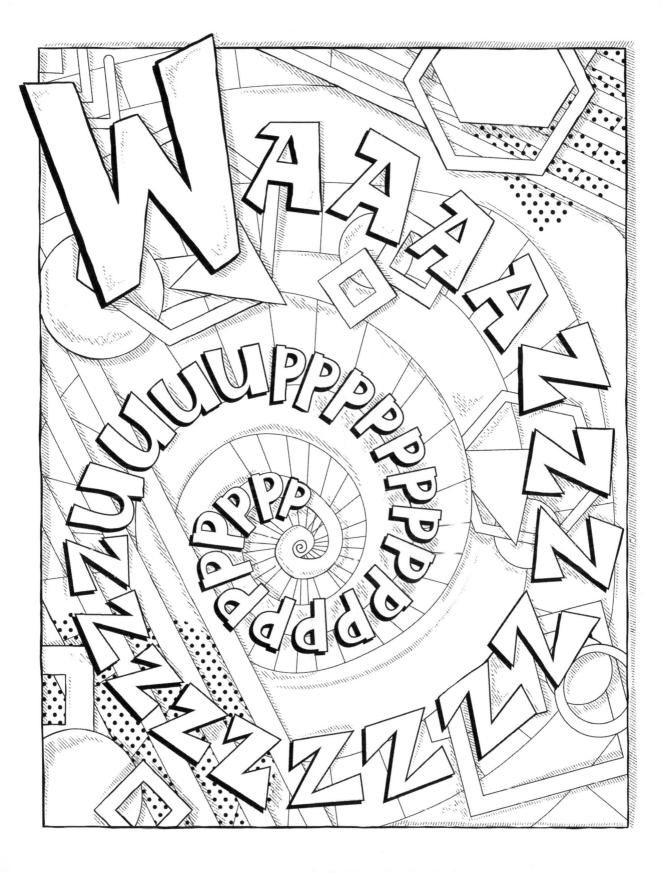

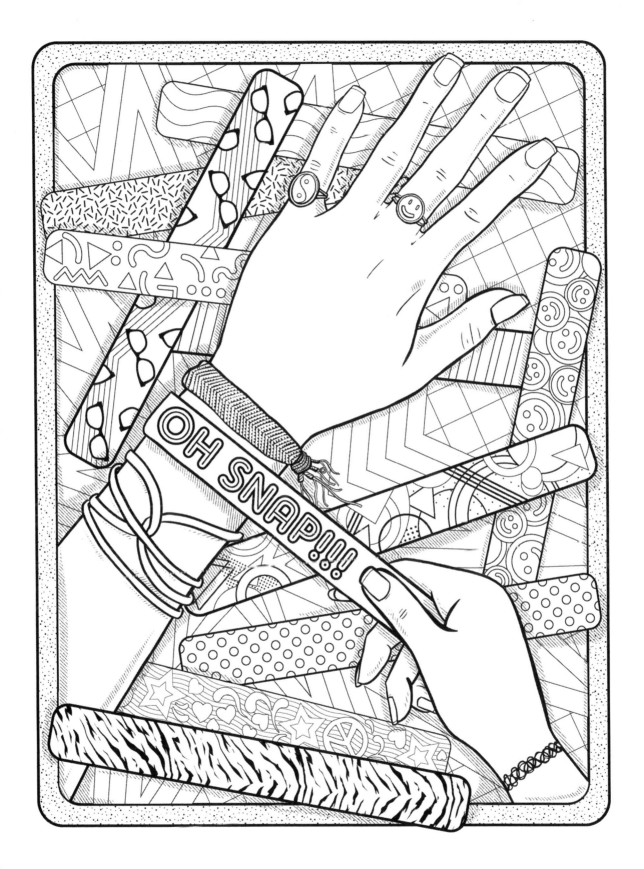

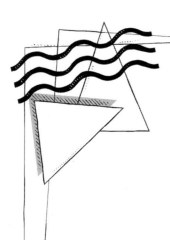

Be still, my nerdy heart! Was there ever a decade for us nerds to shine more than the '90s? Daria, MTV's best-known nerd, taught me that smart girls with glasses are the *real* cool. We had geeky pioneers like Bill Nye, Doogie Howser, Screech, and Steve Urkel showing us you could be your true geeky self and totally steal the show. It's quite a challenge to try and pick a favorite between Screech and Steve Urkel. I always loved how Steve could play a mean accordion while doing the memorable "Urkel Dance." Even though they both could rock a high-waisted pant with a signature suspender, Screech always won the style category with his loud prints and bright colors.

With so many good '90s nerds, how can you possibly choose a favorite?

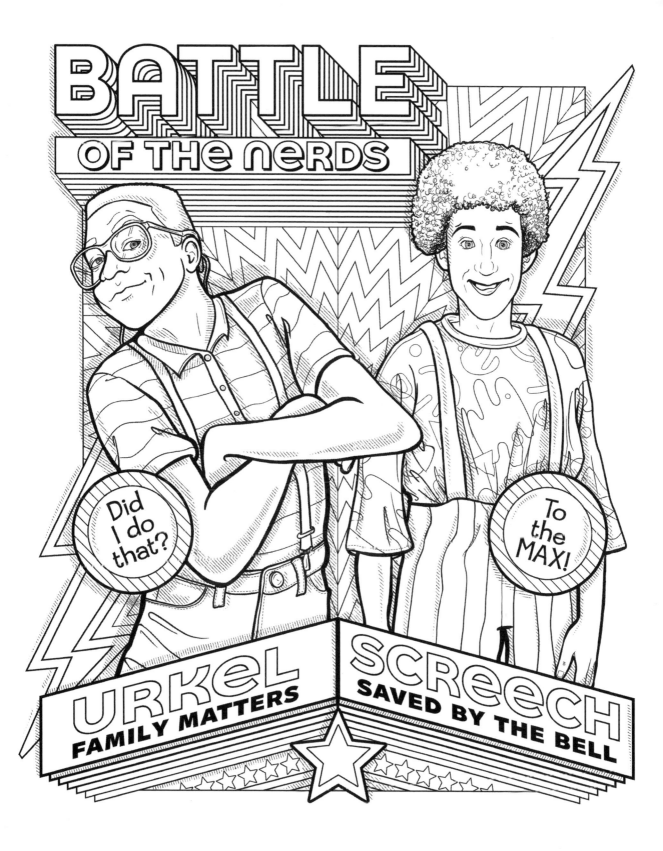

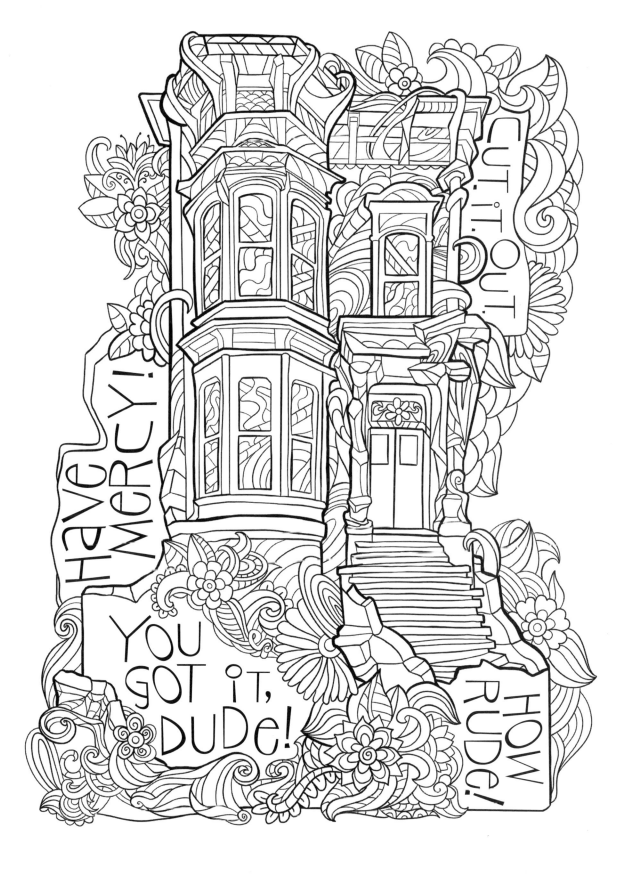

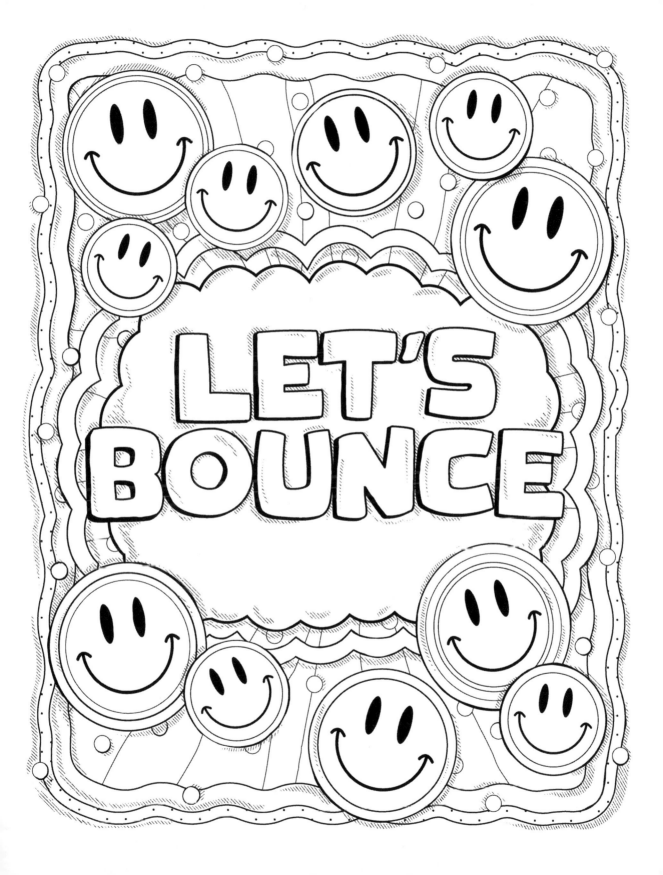

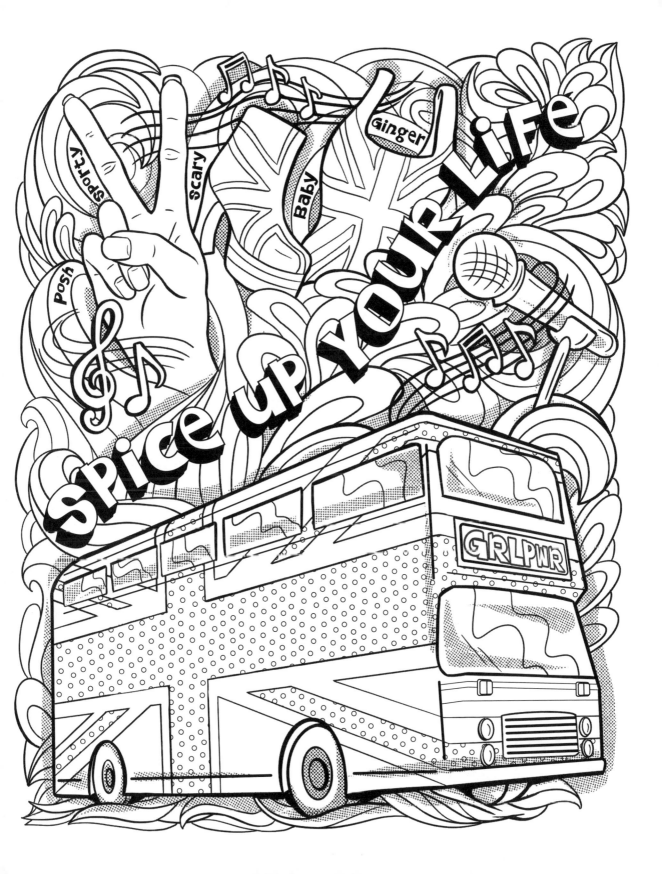

With so many collectible item trends like POGS and Beanie Babies, there's really no way to explain how troll dolls became so popular. Perhaps it was the bright unruly hair and jeweled belly buttons that gave these wrinkly weirdos a contagious charm and an undeniably delightful personality. Do I know why I loved them? No. Did I still want them in every color? Yes.

In 2016 the iconic troll design was revamped, thanks to a new franchise of movies that caused a resurgence in their popularity. Once again, trolls have become a worldwide phenomenon, but lacking their signature original ugly charm. I will always have a soft spot in my heart for the original versions and will not be swayed by their new Hollywood makeovers. If anything, they should be even uglier and dressed in quintessential '90s period garb.

Thanks to Lisa Frank and the bright colors of the '90s, everyone in school was envious of whoever had the newest Trapper Keeper, with matching gel pens and folders. Dolphins, puppies, unicorns, and hearts were covering everything I could buy. I'll never forget the excitement of receiving the latest dELiA*s catalog in the mail. I'd page through and mark off every butterfly clip and platform shoe. . . . Even though I'd rather be outside on Rollerblades playing with Super Soakers, it was fun to play dress-up in my preteen imagination.

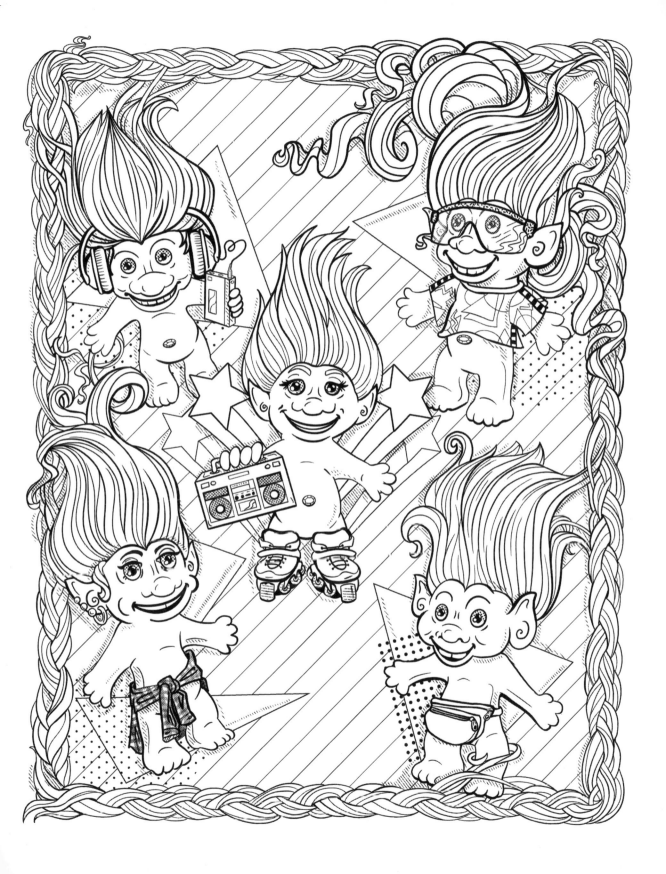

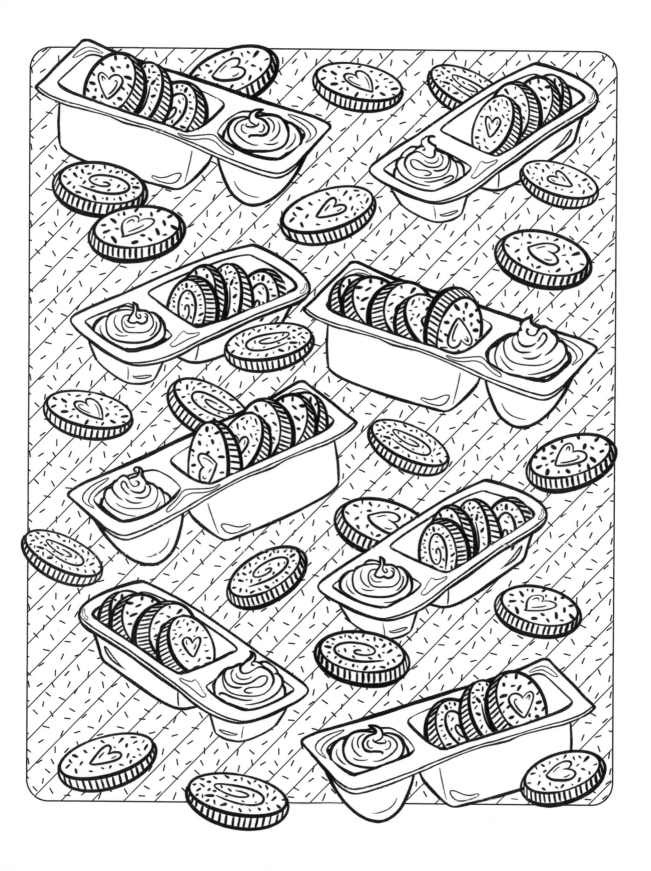

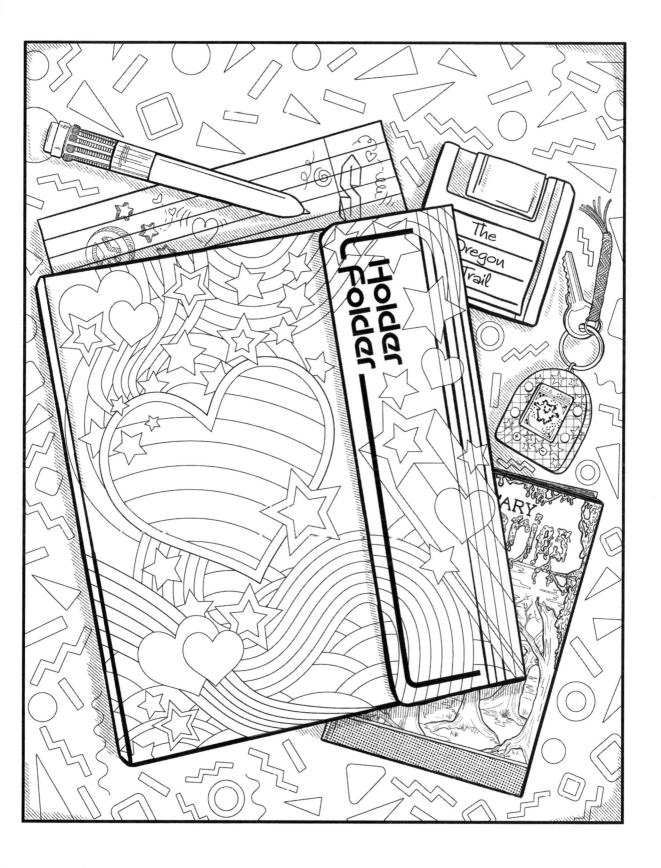

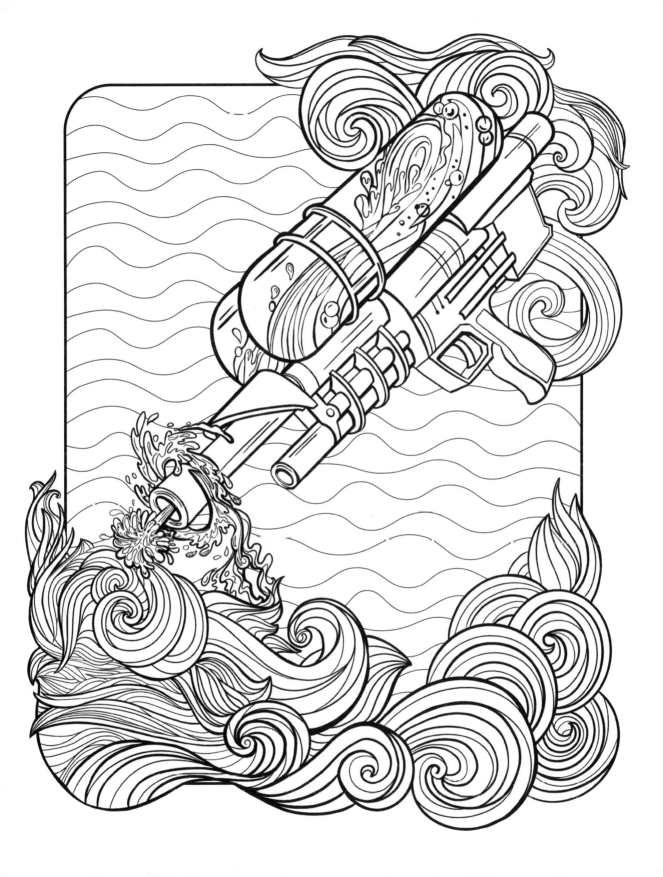

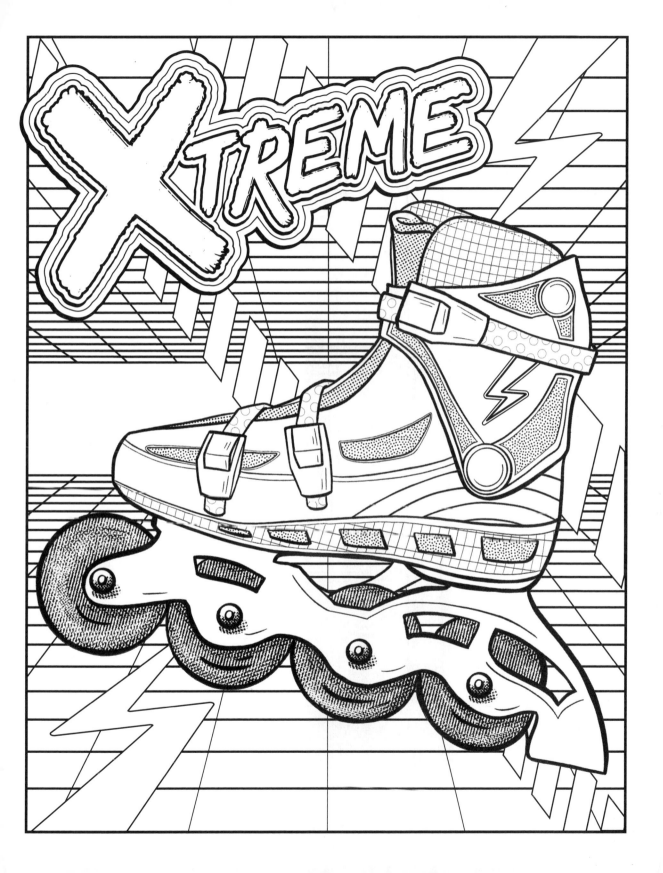

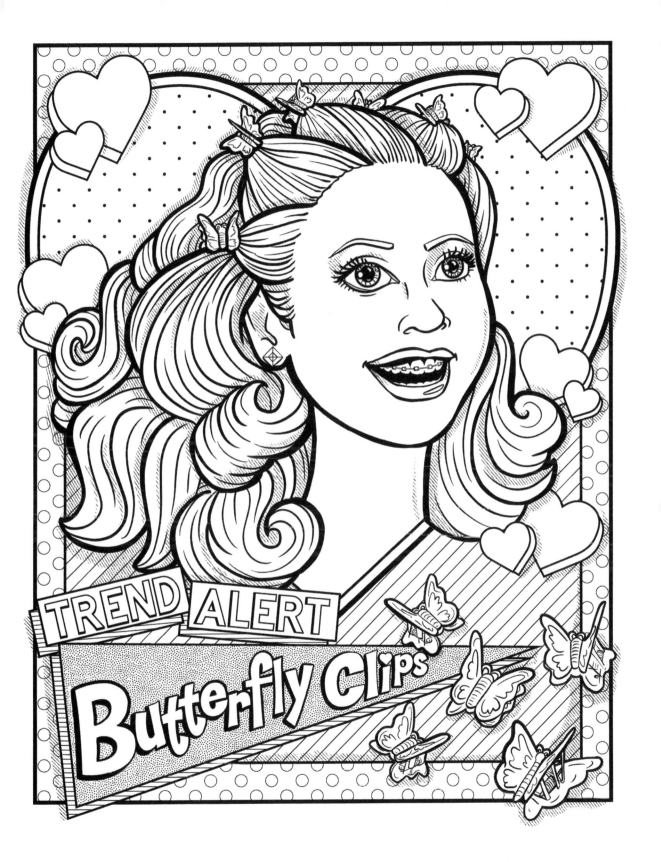

The fashion industry may try to rebrand them as "belt bags," but '90s kids know what these uncool style staples are really called: fanny packs. Maybe it was just practical and convenient to have all your essentials—keys, wallet, pager, etc.—in one place, but really, every trend has its moment and the fanny pack is just too good to ignore. No one was immune to their power— even Dwayne "The Rock" Johnson shared a throwback photo of himself wearing a very classy leather version. (I personally prefer neon nylon, thank you very much.) If anything, he should be wearing more of them—and isn't it more enjoyable to imagine him covered with this fun accessory?

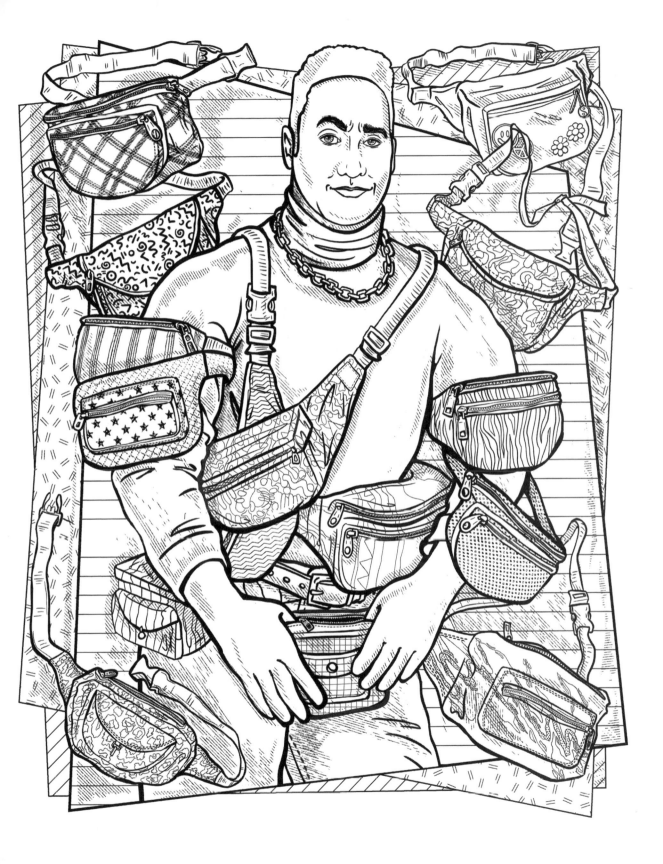

The '90s had so many fun trends with tech. After seeing *Home Alone 2: Lost in New York*, I was so envious of Kevin's Talkboy, a handheld cassette tape recorder that had "speed control" that gave you the ability to change the speed of your recorded voice on playback. We started the decade with our Walkman players filled with mixtapes from friends and ended the '90s creating our own mix CDs. I always had fun coming up with silly names for my mixes, much like Spotify playlists today, but doodling on the blank CDs to make them my own creation was the real fun. I remember the excitement of the Christmas morning when I got my very own Super Nintendo and the endless possibilities that were ahead of me with my very first computer, complete with dial-up Internet. Who can forget the pressure of coming up with a totally unique screen name—and how truly important it was to have ~*yOuR oWn vEry SpeCiAL aWay me$$aGe *~ <333?

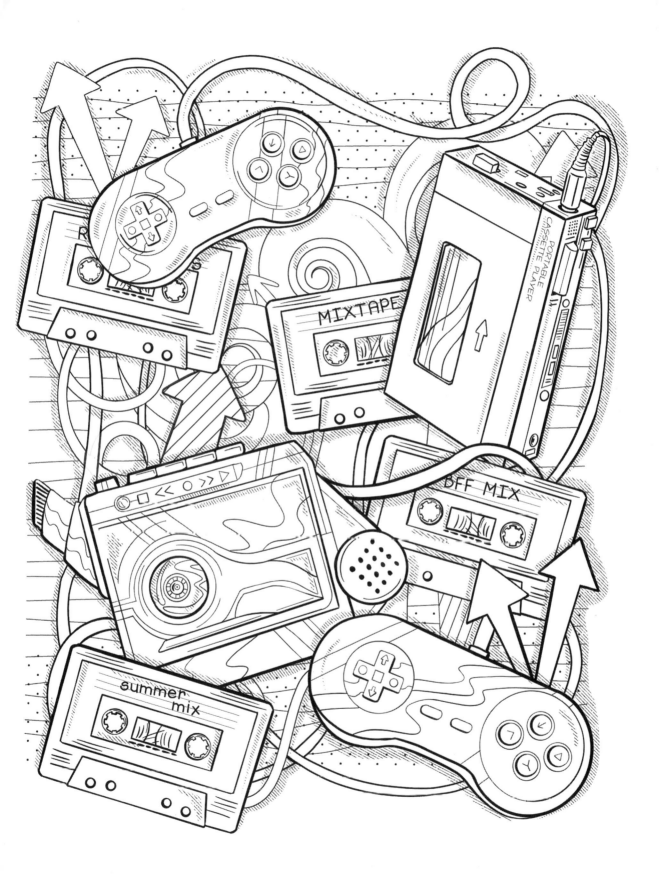

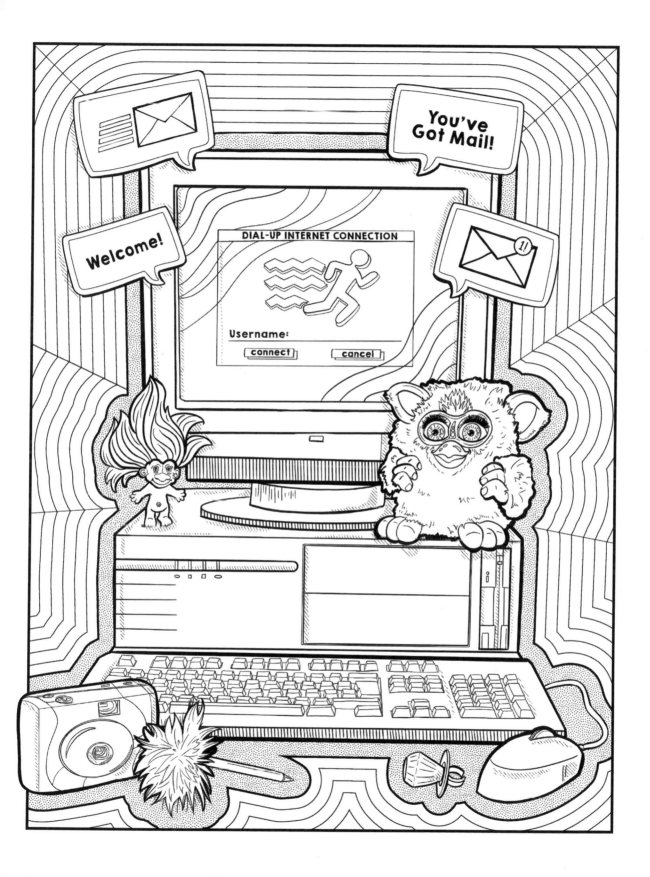

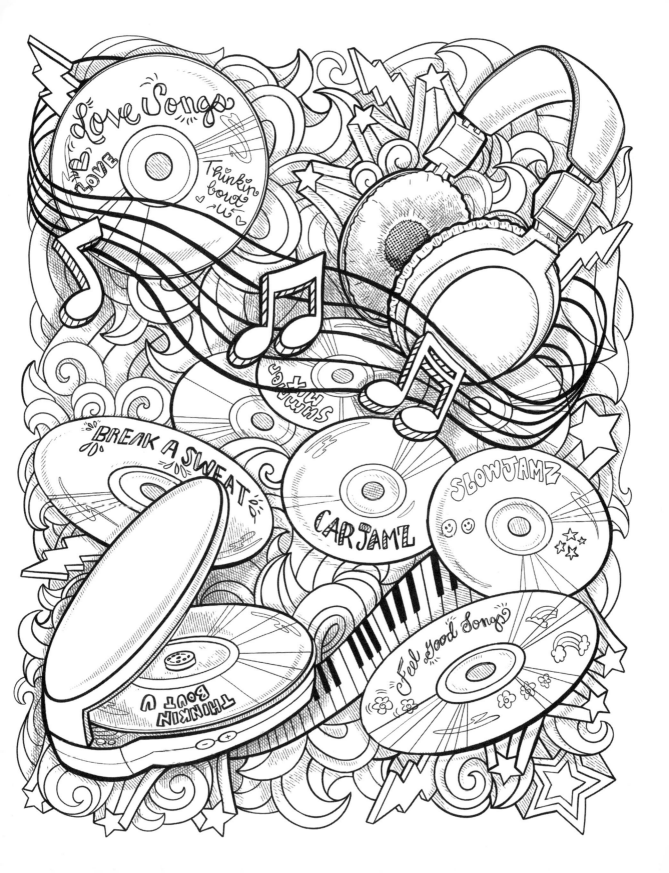

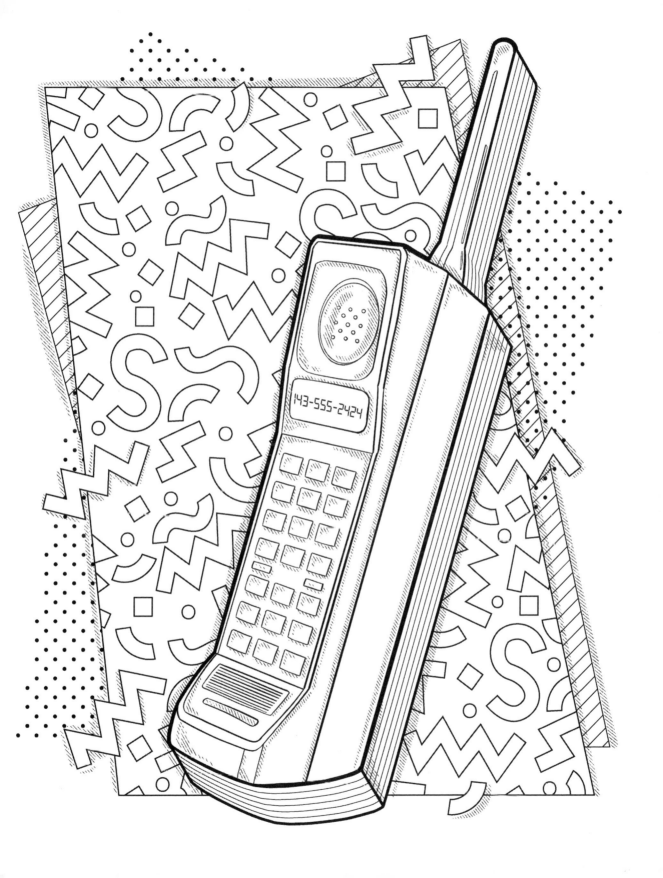

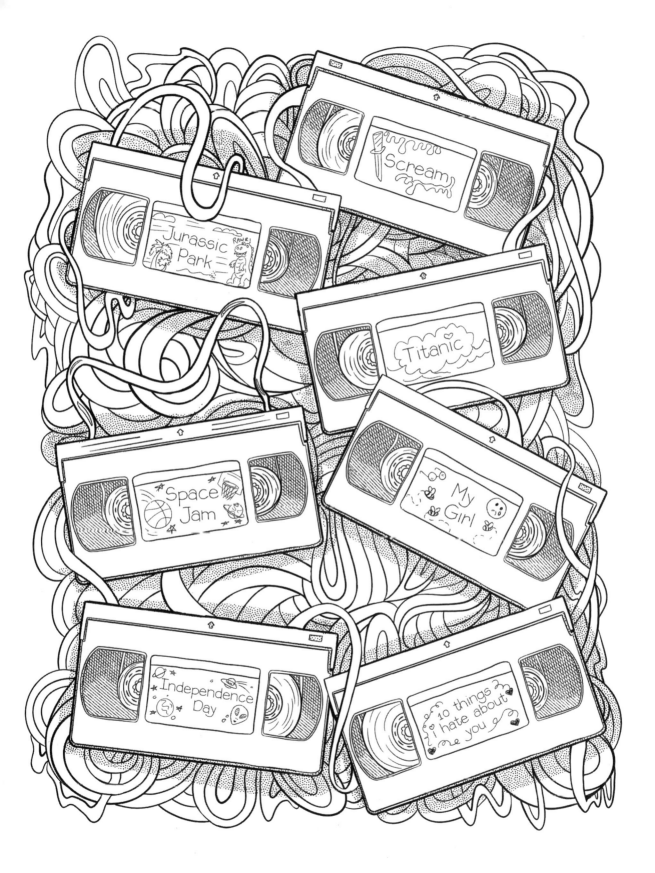

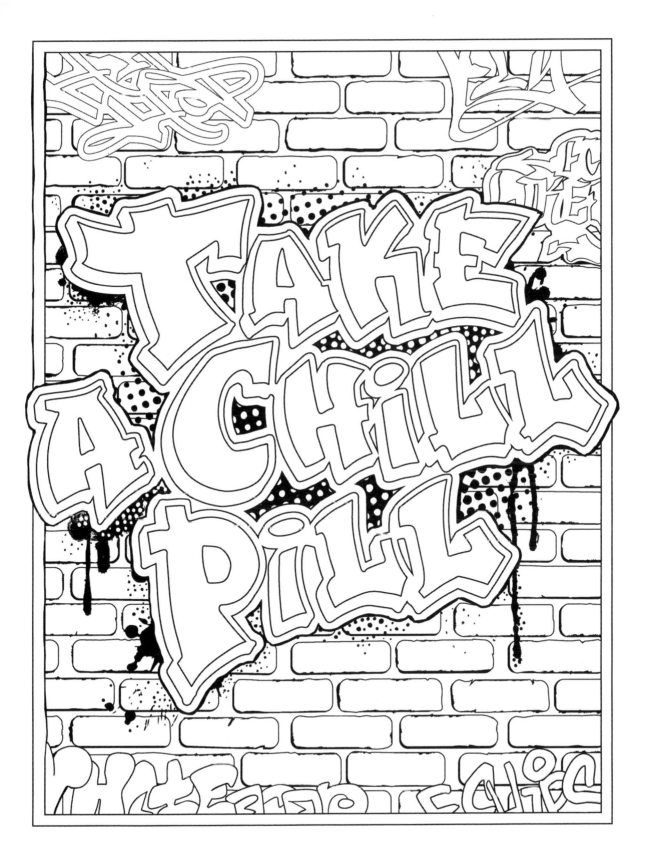

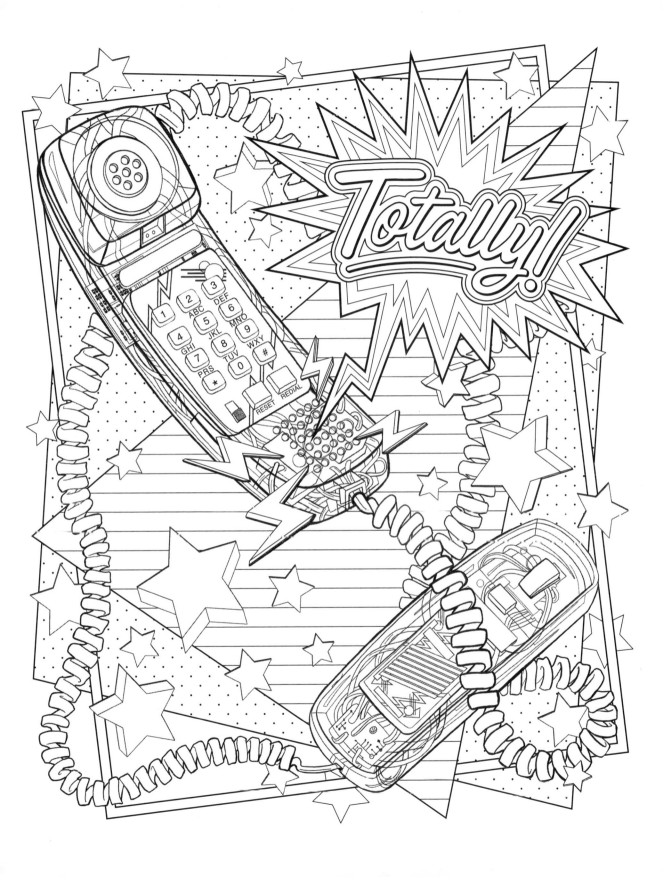

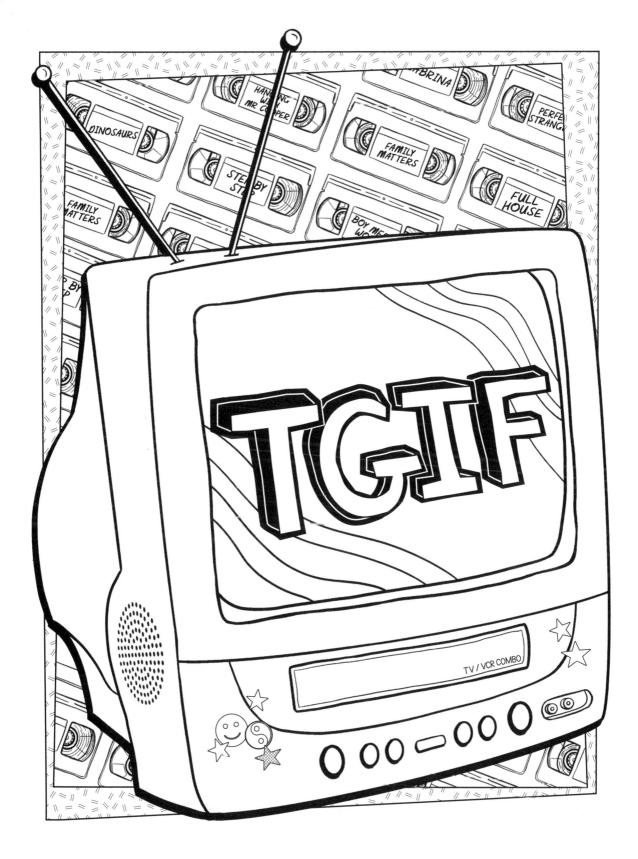

about the author

Christina Haberkern is a designer and illustrator in Los Angeles. She is the owner and creative mind behind Hello Harlot, a stationery and gift-item brand specializing in pop culture and humorous products.

then

now